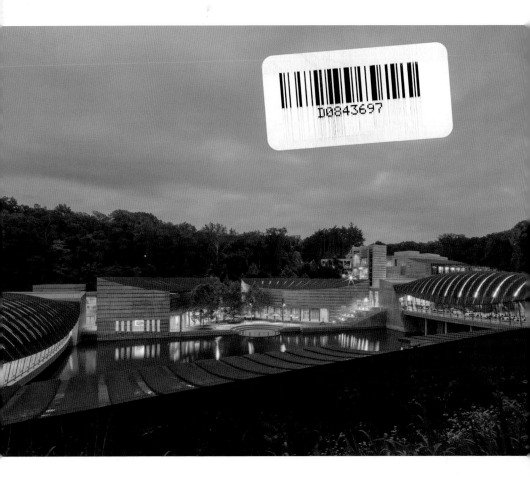

ART IN ARCHITECTURE

Building Crystal Bridges Museum of American Art

To the many skilled craftsmen, designers, architects, engineers, planners, suppliers, landscapers, hydrologists, contractors, and consultants who made the building of Crystal Bridges possible.

Contents

Introduction

The architecture of Crystal Bridges Museum of American Art in Bentonville, Arkansas, is as stunning and inspiring as the artwork housed within. Anchored below the tree line inside a steep natural ravine, the building reveals itself only gradually, initially appearing as a simple line of concrete columns outlined against the sky. A first-time visitor might understandably pull up to the entry drive and wonder, "Where's the museum?" It is not until one gets close enough to peer over the railing that the full scope and power of the structure can be seen and appreciated.

In the hollow beyond the Museum's entry, muscular gray concrete outcrops ascend from the bedrock, banded in rough red cedar and curved to echo the shape of the hillside. The roofs of the Museum's eponymous bridges, bound in strips of deep brown copper, rise like mounds of earth around still ponds.

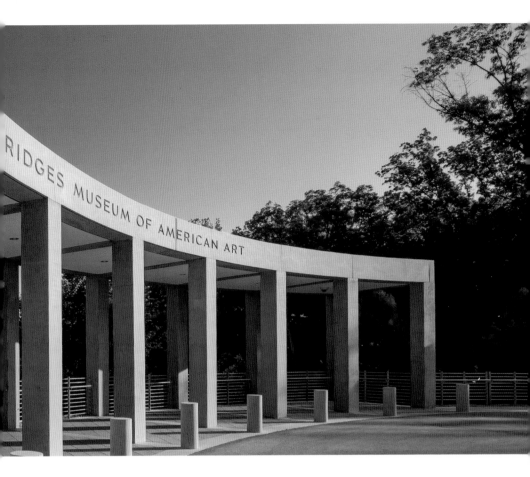

That first view is breathtaking, not only because of its beauty but also for the monumental feats of construction and engineering it implies. The initial "Wow" is often followed closely by "How?" How could this complex and massive structure have come to be?

This book tells the story of the creation of Crystal Bridges: from initial vision and a sketch on a napkin through its complex construction to the institution we know today. A place to enjoy art, architecture, and lifelong learning in an inspiring natural setting, the Museum has become a destination for people from around the region, the nation, and the globe.

Thank you for being a part of that journey.

History

"To me, people everywhere need access to art and that's what we didn't have here and that's why Crystal Bridges is so important. It's important that it be located here."
ALICE WALTON, *CRYSTAL BRIDGES FOUNDER AND BOARD CHAIR*

Crystal Bridges Museum of American Art was founded by Alice Walton, daughter of Helen and Sam Walton. She grew up in Bentonville, Arkansas, the small town where her father owned the five-and-dime that would eventually become Walmart. Walton had an interest in art from early childhood. On family camping trips, she and her mother would often paint watercolors of the landscape, and her first art acquisition was a reproduction of Picasso's *Blue Nude*, which she purchased with money she earned by working in the store. With no major museums nearby, however, Walton's access to original works of art was limited, and her early interest was fed primarily through pictures of artworks in books and magazines.

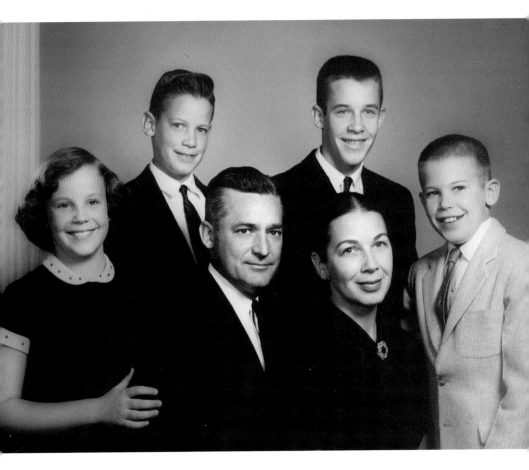

As an adult, Walton's interest in art expanded as she began to collect American watercolors and to learn more about the lives of the artists who had made them. Discovering that her appreciation of American history was sharpened by the perspective she gained through the study of American art, she became determined to make firsthand experience of great works of art accessible to future generations in the region. This desire became the driving force behind the creation of Crystal Bridges.

Over time, the Walton family acquired a swath of land near the heart of Bentonville that included a forested ravine where Walton and her brothers played as children. Helen Walton spoke of this piece of land as being reserved for "something special." As the idea of creating a museum of American art blossomed in Alice Walton's mind, she imagined it coming to fruition here—to serve as a celebration of both the land and the art she loved, and as a lasting gift to the community.

Above: The Walton family

Below: Alice Walton

In 2005 Walton discussed her vision for building a major art museum in Bentonville with the Walton Family Foundation board. Her enthusiasm was matched by the board's collective excitement, and they decided unanimously to move forward with the project.

Enter Moshe Safdie

With a location chosen for the project, Walton's next step was to select an architect. Her love of art had taken Walton to museums around the world, but she knew this one had to be different. The building must serve not only as a safe home for the art but as a welcoming haven for the community and a tribute to the natural environment. It had to work in harmony with the Ozark landscape and offer a way for visitors to interact with nature as a part of their experience. The architect would need to be sensitive to all of these elements.

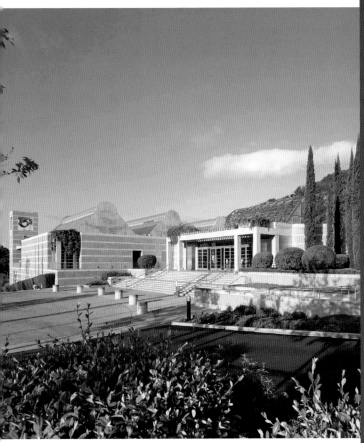

MOSHE SAFDIE

Moshe Safdie is an architect, urban planner, educator, theorist, and author. He has completed a wide range of projects, including cultural and civic institutions, neighborhoods, airports, and master plans for communities around the world. Born in Haifa, Israel, in 1938, Safdie relocated to Canada with his family in 1953. He graduated from McGill University in 1961 and apprenticed with Louis I. Kahn in Philadelphia. In 1964 he established his own firm to realize Habitat 67, the central feature of the 1967 World's Fair and a groundbreaking design in the history of architecture. Safdie's work includes the Skirball Cultural Center in Los Angeles; the Holocaust History Museum at Yad Vashem, Jerusalem; and Marina Bay Sands resort in Singapore. He was awarded the Gold Medal from the American Institute of Architects in 2015.

The Skirball Cultural Center in Los Angeles was Walton's introduction to the architecture of Moshe Safdie. A multiuse structure built into a rocky hillside, the Skirball provided inspiration for the materials and design of Crystal Bridges, with its concrete and wood-banded walls. Struck by the way the building worked with the landscape, Walton invited Safdie to visit her family home in Bentonville. On a cold November day, they walked the site together, talking about the unique qualities of the land and what Walton envisioned for the new museum. At the end of the visit, Safdie asked Walton if she had officially begun to search for an architect. "I've just chosen one," she replied.

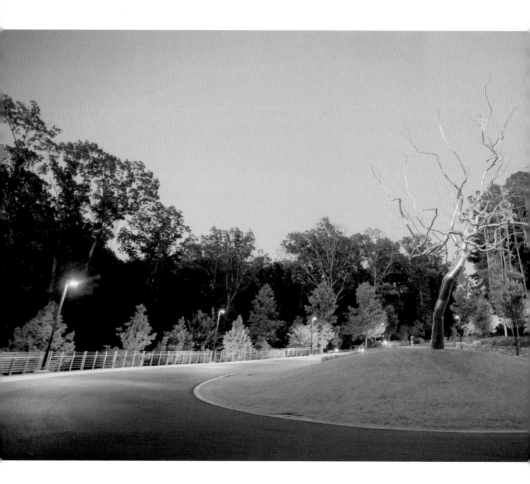

The Plan: Inspiration to Design

"For me the first spark, the seed of a design, often occurs when I first visit the site. It is a kind of detective process, seeking to decode its secrets. I cannot, therefore, work on a design if I have not visited a site." MOSHE SAFDIE, *ARCHITECT*

Once Moshe Safdie was officially on board as the project's architect, he began to generate ideas for the design of Crystal Bridges. On his first visit to the site of the future museum, Safdie was struck by the beauty and character of the Ozark landscape. Maintaining that natural beauty was foremost in Alice Walton's vision for the development of the land. Safdie, in turn, wanted to incorporate the landscape into his design, allowing guests to the Museum to experience both the art and the natural setting during their visit.

Seeking inspiration, Safdie and Walton each traveled to a number of cultural institutions, including the Amon Carter Museum of American Art in Fort Worth, Texas, the Getty

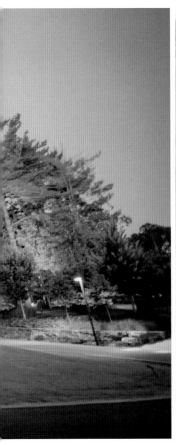

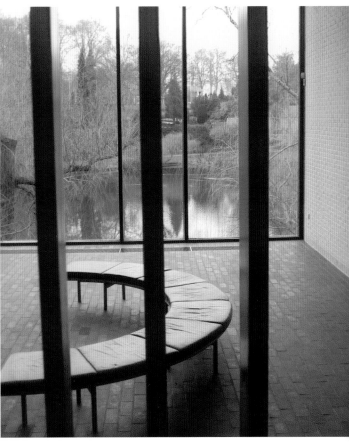

Center in Los Angeles, and the Louisiana Museum of Modern Art in Denmark, as well as several regional buildings. They were exploring how people flow through museums, how the museum buildings offer places for communities to gather, and how the structures are integrated with their natural sites. At the Louisiana Museum, for example, they were inspired by the floor-to-ceiling glass walls that allow natural light to enter the building and provide guests with views of the outside.

Fay Jones and the Architecture of the Ozarks

In designing Crystal Bridges, Safdie was also inspired, in part, by the work of Arkansas architect Fay Jones, who had designed the Walton family home in Bentonville. Jones was among the first students in the new Department of Architecture at the University of Arkansas following World War II. He also studied under Frank Lloyd Wright as a fellow at Taliesin, Wright's home and studio, and was deeply inspired by Wright's emphasis on a structure's connection to its site.

In opposition to the International Style of architecture, which strove to remove any local context from a building's design, Wright sought to develop a uniquely American style that was deeply rooted in the landscape. He connected to the land by building across the ground rather than up and away from it, and by using simple, natural materials in construction.

As Jones developed as an architect, he amplified Wright's principles by further engaging his structures with the unique topography of the Ozarks. Thorncrown Chapel, located just outside Eureka Springs, gracefully articulates Jones's deep understanding and appreciation of the landscape of Northwest Arkansas.

In 1956 Jones designed a home for the Walton family based on Wright's essential principles, adapted to the spirit of the Ozarks. The house's clean lines frame light-filled spaces with views of the outdoors. The site includes a natural stream, which Jones dammed to create a pond that interacts with the architecture of the house. This inclusion of the natural waterway made an impression on Safdie during his initial visit, and later it inspired the basic design for Crystal Bridges.

Location, Location, Location

To determine where on the property the Museum would be built, a scale model of the entire site was constructed and various options were explored. "We made some studies of being on top of the hill," Safdie said. "But it took a lot of pine trees down, and so I started thinking: Could we go into the valley itself and save some of the pine trees?"

One afternoon, while exploring the site on foot, Safdie remembered Jones's inclusion of a natural stream in his design for the Walton home. Later he explained: "We were walking along the stream and it dawned on me—having visited the [Waltons'] family house and seen the pond that was created by damming the stream—that that's the secret of this place. That we should dam the stream—that we would get ponds, and around those ponds, like the old mill towns of Arkansas, we could build around the water."

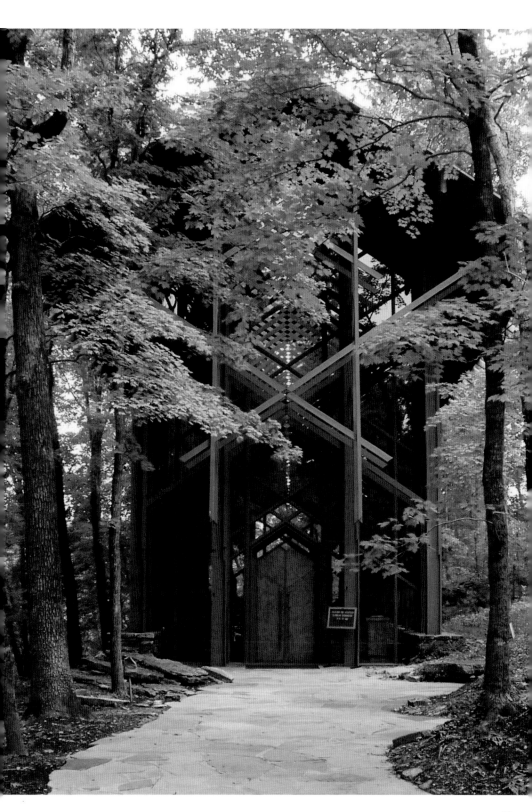

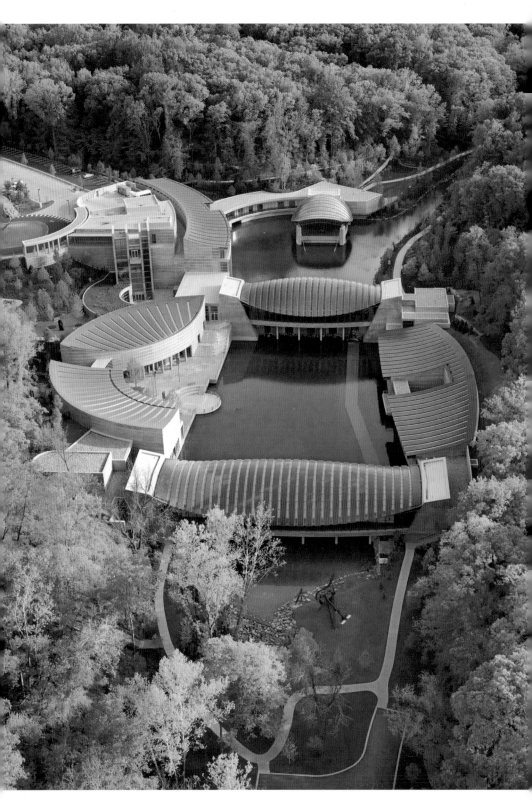

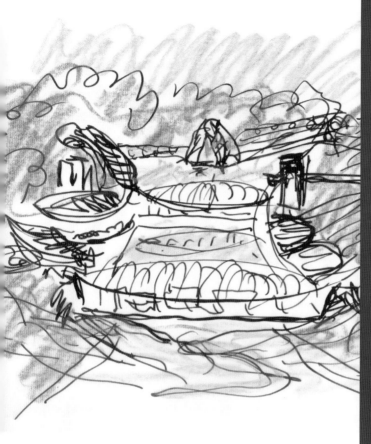

Safdie began developing his design around this concept. He envisioned a series of buildings on both sides of the water, nestled into the ravine and joined by bridges. Their curved roofs reflect the forms of surrounding topography, and the concave roofs of the side buildings continue the downward line of the ravine's edge. In addition, the materials Safdie chose for the construction of the buildings are intended to weather over time, acquiring a gentle patina that helps the structure blend in as a natural part of the landscape. Safdie's early "napkin sketch" of his plan for the Museum shows how close his initial concept was to the final product.

THREE GOLD MEDALISTS IN NORTHWEST ARKANSAS

Frank Lloyd Wright received the American Institute of Architects' Gold Medal, the Institute's highest honor, in 1949. Fay Jones, Wright's student, was awarded the Gold in 1990, the only Taliesen Fellow ever to receive this honor. Moshe Safdie was awarded the AIA Gold Medal in 2015.

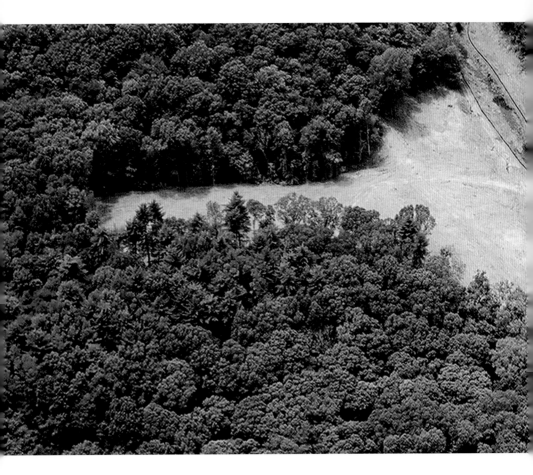

Engineering and Construction

"I believe that architecture is unique among art forms: similar in aspects of structure, poetry, and invention, but different fundamentally. Three basic and essential elements constitute this distinction: first, 'purpose'—the manner in which architecture accommodates life; second, 'tectonics,' derived from the Greek tektonikos—*the materiality of architecture and the technology of building; and third, 'place.' Architecture, unlike many other art forms, is rooted in time and place."*
MOSHE SAFDIE

Moshe Safdie's vision for Crystal Bridges was profound in its easy interaction with nature—the Museum was to appear as if it had always been part of the landscape. Safdie designed a structure that elevates along with the ravine, from the water level to the crest of the hillside: a structure that blurs the line between natural and built environments.

The articulation of Safdie's plan was extremely challenging. The largest and most difficult construction project ever

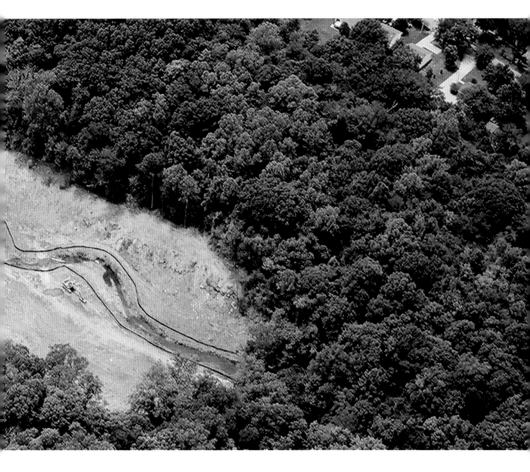

attempted in the region, it required a number of engineering feats and called upon the hands and minds of more than 350 workers and craftsmen, as well as a host of engineers and architects.

This aerial view shows the minimal amount of clearing done prior to construction of the Museum.

Earth and Stone

The construction team broke ground in 2007, the beginning of a laborious five-year process of building an art museum in a rocky Ozark forest. Keeping as much of the natural site as undisturbed as possible drove the logistics of the construction of the entire Museum campus. The plans called for a minimal six- to nine-foot zone of disturbance between the edge of the structure and the surrounding forest. Trees were removed only if they would have direct interference with the building. In fact, the building design itself was adjusted to accommodate one particular set of mature tulip trees that grow near the edge of the site (see page 19). Wood from felled trees was stored for later use, including the construction of the benches found in the Museum galleries.

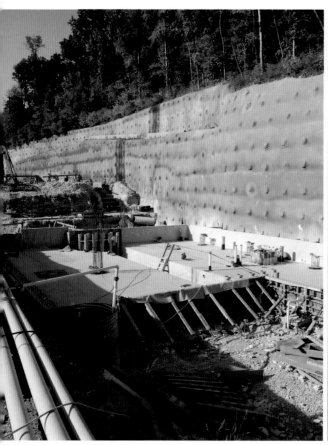

The heads of dozens of soil nails, which help stabilize the surrounding earth and rock, can be seen here in the excavation wall.

Some was given to regional wood turners, who have transformed the pieces into handcrafted works of art for sale in the Museum Store.

When the site had been cleared, the crew began excavating the hillside to make room for the gallery buildings that would flank the ponds. In all, some 170,000 cubic yards of soil and rock were removed from the site.

The form of the side buildings follows the natural shape of the ravine because the structure depends on the ravine for support. The backs of the buildings are formed of solid concrete walls built against the edge of the excavation. A process called "soil nailing" made this possible. Some 680 12- to 20-foot-long nails were drilled horizontally into the earth around the excavation site and secured with a layer of spray-on concrete. These keep the hillside in place and also help minimize disturbance to the surrounding landscape.

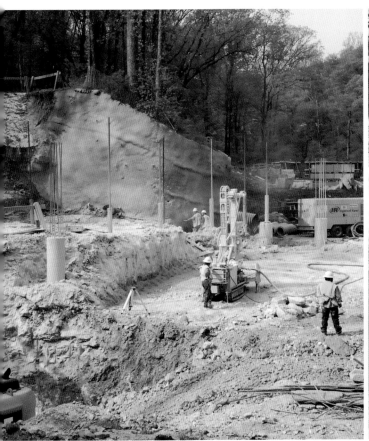

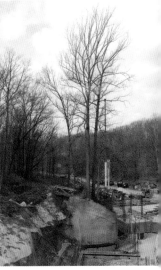

Water

One of the primary design and engineering challenges involved in the construction of Crystal Bridges was water. Town Branch Creek discharges 500,000 gallons of water through the site on an average day, and considerably more after heavy rain. The design would have to manage water flow, holding back enough to create the ponds while releasing enough to minimize the risk of flooding.

Safdie began experimenting with different dam configurations. At last he lit on a system of labyrinth weirs—zigzag-shaped walls that serve as dams to create the ponds but are capable of discharging a great deal of water quickly when the stream is in flood. The result was not one pond but two, joined by a weir that becomes a 10-foot waterfall when it rains. A second weir regulates the flow of water out of the Museum's lower pond back into the natural stream.

Above left: Excavation at the Museum site in progress.

Above right: Building plans were changed to save this set of tulip trees, now known as "Thelma and Louise," at the edge of the construction zone (see page 50).

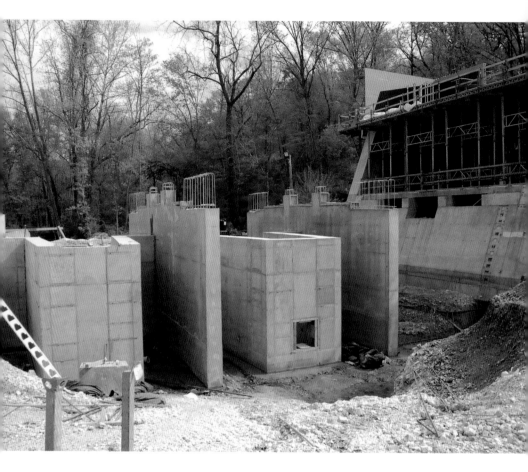

The zigzag shape of the labyrinth weirs under the Museum's gallery bridge can be seen in this construction photograph.

Town Branch Creek was redirected through underground pipes during the building of the Museum, bypassing the construction zone and reemerging to the north. This was not the only water challenge the engineers faced. The abundance of underground water in the area meant that the construction team frequently had to redirect groundwater that seeped into the site. Each time they encountered a water-bearing layer of soil, the engineers were obliged to install a system of pipes to carry the water away. By the time construction was complete, the crews had installed an estimated five miles of subsoil drainage pipes.

Concrete

Architectural concrete is the essential element that allows for the articulation of Safdie's design. Formally, the concrete represents the visual continuation of the land. The weirs connect with the earth on the bottom and tie into the abutments on the side—establishing the new base for the gallery or restaurant spaces above. A series of vertical

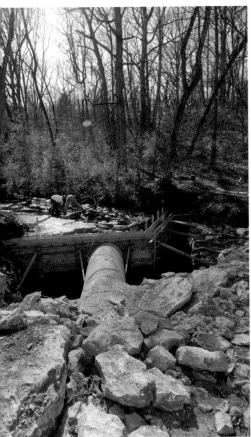

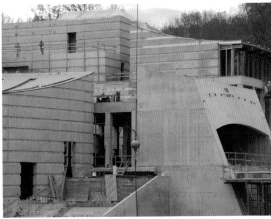

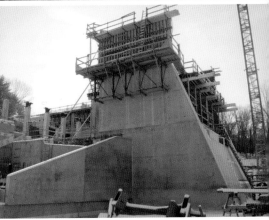

elements rise from the weirs to the concrete floor of the bridges above the dams. Continuing the interdependent structural dance of the bridges, the abutments rise—"extending the ground skyward," as Safdie says.

To accomplish the design, a massive amount of architectural concrete was required. The underground walls of the buildings are 18 to 24 inches thick, and the upper walls 12 to 18 inches thick. In order to support the roof structures, the concrete bridge abutments had to extend to the bedrock, up to 35 feet into the earth in some areas. This process was more complicated than initially expected, as the limestone and sandstone site was riddled with natural voids that had to be filled as the piers and walls were poured. In the end, nearly 50,000 cubic yards of concrete were used.

Architectural concrete has a more refined surface than regular concrete, and small changes in the mixture can result in color variations in the finished product. In order

Left: Underground pipes channeled the water from Town Branch Creek away from the site during construction.

Top right: Nearly 50,000 cubic yards of concrete were used in building the Museum.

Bottom right: A set of coated plywood forms in place for casting a segment of bridge abutment.

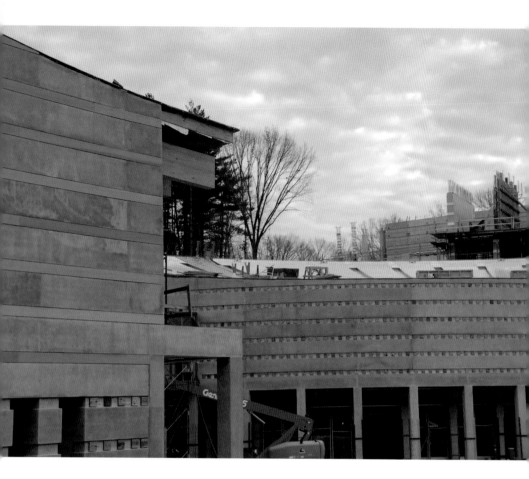

Installation of the cedar banding can be seen here in stages of completion.

to produce the highest-quality architectural concrete, and maintain a consistency of color, all of the concrete was mixed on site in a temporary facility that was erected on the west side of the ravine.

The Museum walls, abutments, and piers were created utilizing a cast-in-place technique: the metal forms, lined with slick, coated plywood, were fabricated on site. Strips of precisely cut dense structural foam were placed inside the forms to create the insets for the cedar banding that would later grace the exterior walls. Each set of forms was lifted into place by crane, filled with the architectural concrete, and left to cure for 14 days. After the walls were formed, the concrete was hand polished to a finish as smooth as marble.

Wood

Wood is also a primary building material of Crystal Bridges: Arkansas southern yellow pine beams support the roofs; the gallery floors are made of oak milled in Monticello,

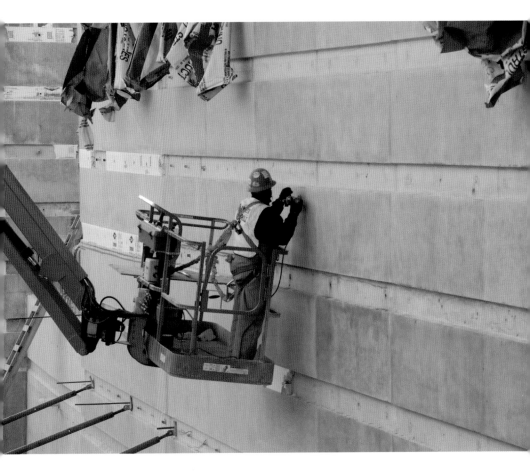

Arkansas; and bands of red cedar wrap the entire structure, creating long horizontal lines that complement the upward thrust of the windows and columns.

Approximately 20,000 linear feet of red cedar heartwood were used in the Museum's exterior banding. Cut from the center of the tree, heartwood is denser than wood from the younger, outside layers, and features a clear, vertical grain with no knots.

The Bridges

Safdie's design called for expansive, bridgelike elements to cross the natural waterway and support the glass-enclosed gallery and restaurant spaces. These bridges are a unique place where the structural elements of the building unite. All of Safdie's principles (purpose, tectonics, and place) unite with the design and engineering of the bridge/dam system. Large geometric abutments rise from the bedrock, mimicking a sculptured rocky outlook.

A worker using an electric polisher to finish the concrete walls.

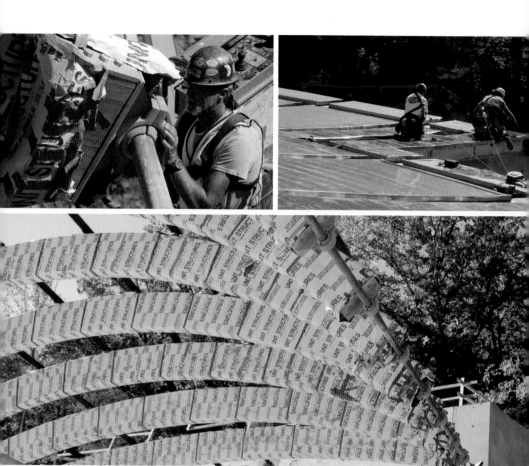

Top left: A construction worker installs the clamp that attaches a roof beam to one of its support cables.

Top right: Construction workers installing copper cladding on the Museum roof.

Bottom: Installed beams, still in their protective wrapping, give shape to a bridge roof.

Four-inch cables, anchored in the abutments at either end, support the entire weight of the wood-and-copper roof system and glass walls. Once the cables were strung, the enormous roof beams were lifted in and attached to the cables at either end. The beams serve as structural elements for the roof and also determine the curvilinear form of the space. Each of these beams was constructed of layers of wood, glue-laminated together then bent into the necessary shape using steam and pressure. The largest beams are 12 inches wide and 31 inches deep, made from nine layers of wood. The beams in the roof of the restaurant and the Great Hall, which feature a secondary curve, are composed of 27 pieces. The beams had to be built to very precise specifications, and each one is slightly different. A national search was conducted to find a company that could make them. Eventually, the right fabrication team was discovered in Magnolia, Arkansas. Remarkably, not a single beam had to be rebuilt.

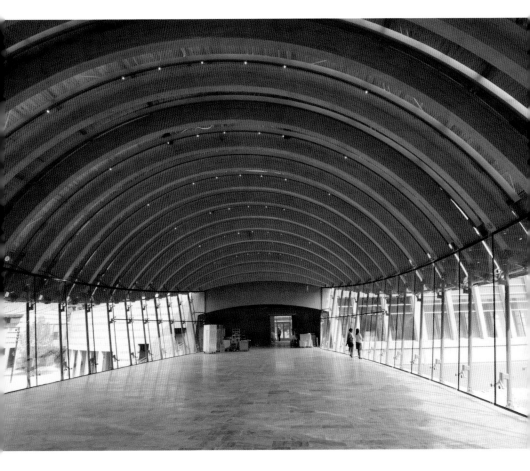

With the roof beams installed, the bridges were finished with glass walls, skylights, and copper cladding. Copper also covers the concave roofs of the side buildings. All told, more than 184,000 pounds of copper were used in construction of the Museum's roofs.

The glass curtain walls of the bridges help create the illusion that the massive roofs are floating unsupported. The walls are made of two 3/4-inch panes of glass with airspace between them, and are canted outward at the top by about 12 degrees, contributing to the overall expansive feeling of the interior space. "Spider" connections, supported by vertical poles that can be seen along the restaurant and gallery bridges, hold the large panes in place. These joints allow the glass to shift with the roof, which can move side to side due to changes in temperature. The glass is attached to the roof and floor with specially designed accordion joints that let the walls flex independently of the roof.

The roof of the finished restaurant bridge appears to float over its glass walls.

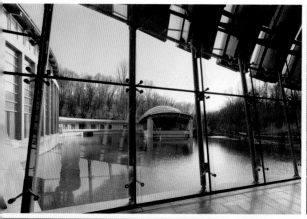

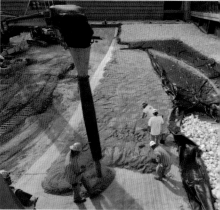

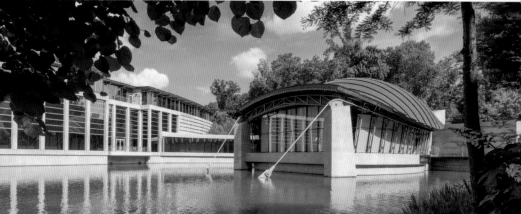

Top left and above: View of the finished upper pond.

Top right: Workers pour layers of geosynthetic clay to line the base of the Museum's lower pond.

The Ponds

The ponds were the last element to be completed in construction of the Museum. Though they appear quite naturalistic, a great deal of engineering went into their design and construction. Extensive hydrology studies were conducted, based on historic high-water levels and projections of possible future rain events. In order to be certain of the long-term safety of the artwork housed inside the Museum, these studies factored in levels for a 100-year flood, then a 500-year flood, and finally a projected 1,000-year flood* to determine the optimal design for the ponds. The bottom of the ponds is lined with several layers of geosynthetic clay liner—a combination of synthetic material and red clay—that is installed in long strips: first running north and south and then again running east and west, creating an impermeable floor. Wherever the liner meets the building structure, it is sealed with a waterproof material called bentonite.

The upper and lower ponds contain 2.2 million and 1.4 million gallons of water, respectively, and are about eight feet deep. Water moves through the ponds continuously via a central groove in each of the weirs. Strong pumps placed at strategic points around the ponds help keep the water moving and prevent stagnation. Underground pipes have been installed so the ponds may be drained and cleaned if need be: a chore that will likely be undertaken only about every eight to ten years.

A Building with Soul

"*Form derives from structure…. This deeper meaning of structure as not only the skeleton but also the skin, arteries, and veins of a building implies that the structure has a soul.*"
MOSHE SAFDIE

There is a visual tension in the architecture of Crystal Bridges, born of the melding of nature and structure. Tension can be seen in the support of the roofs of the bridges and the Great Hall. Tension is evident in the way the building climbs from the water to the crest, in actual and figurative stair steps. This blurs the line between the natural and what is built, what is structure and what is ornament. Safdie utilizes tension in his design because it ties the purpose of the building to the technical construction, and to the place. The unification of these elements creates what Safdie refers to as the "soul"—the unexplainable human connection to the building.

When hard-engineered elements of the Museum meld with the ephemeral moments unique to human interaction with a place, the soul of Crystal Bridges is revealed.

* Moshe Safdie later referred to a "4,000-year-flood" study—an exaggeration meant to emphasize the thoroughness of the hydrology studies conducted at the site.

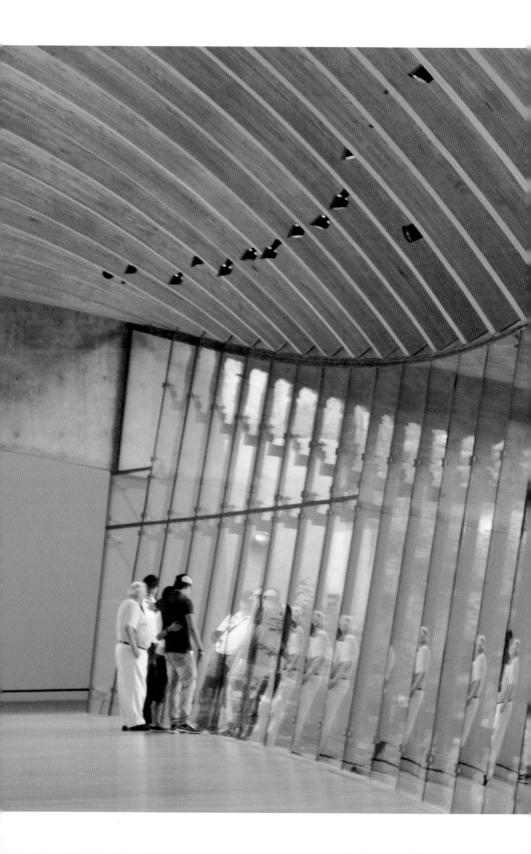

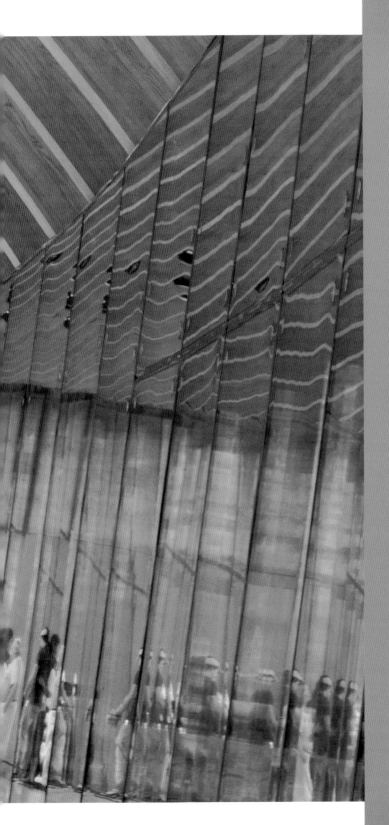

Experiencing
Crystal
Bridges:
Architecture
Highlights

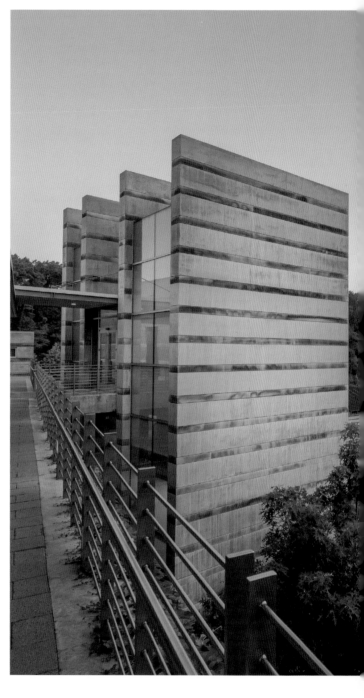

"The concept of 'going down in' and 'not looking up' was a key part of the planning of the Museum. I get hundreds of thank-you notes every year ... and these kids say 'I've never been to a museum, I thought only rich people went to museums. I didn't know we could go. Thank you!' You read these notes and you understand why you shouldn't be sitting up in the air. You see why you should be exploring something that unfolds a little at a time. That's the beauty of what Moshe's done here."

ALICE WALTON

Unlike at most museums, visitors to Crystal Bridges must travel down rather than up to enter the main lobby. The building rests inside a natural ravine. The simple colonnade at the main entrance gives no hint of the extensive scope of the structure below.

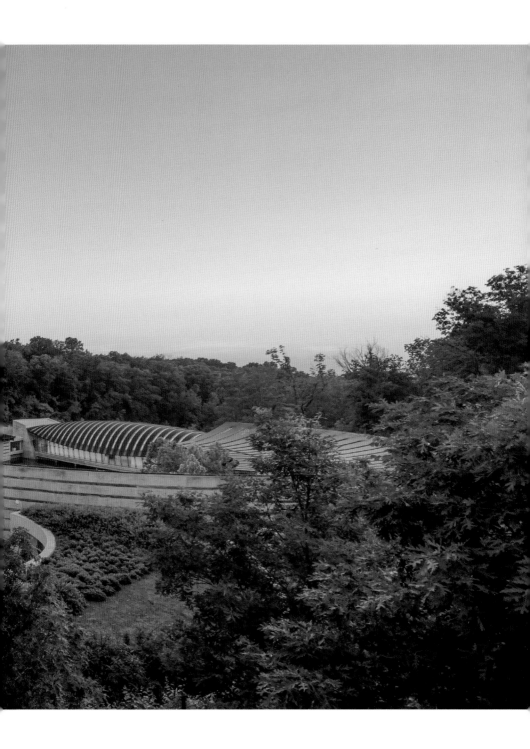

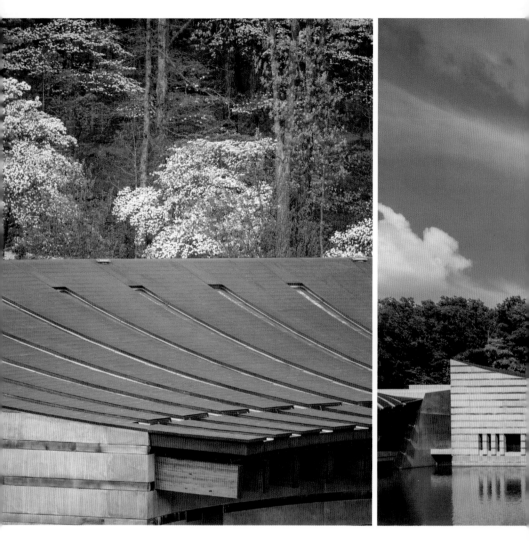

The side-buildings' roofs rise to a level with the edge of the ravine, and their concave lines continue the shape of the slope behind them.

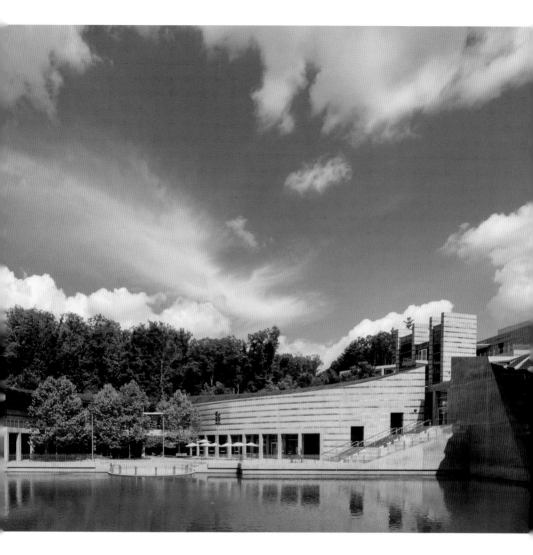

The curvature of these roofs is based on a geometrical shape called a "toroid," a donut shape that is formed by rotating a circle around an outside center point. In the case of Crystal Bridges, that center point would be located somewhere up in the sky, and the donut would be standing on its side, its curve gently cradled by the concave roof.

"I think the geometry, which I'm passionate about in architecture, grows out of an understanding of structure, the possibilities of the materials.... If you take the convex beam and you follow the curve of the land as we have, then you end up with a toroid, the surface of a donut, that's inevitable geometrically."

MOSHE SAFDIE

"First we designed to the 100-year flood, and then it was the 500-year flood, and then they said the 4,000-year flood. And I opened the Bible, and I figured: 4,000-year flood? We're going down to Noah! So now I say it's designed to the 'Noah flood.'"

MOSHE SAFDIE

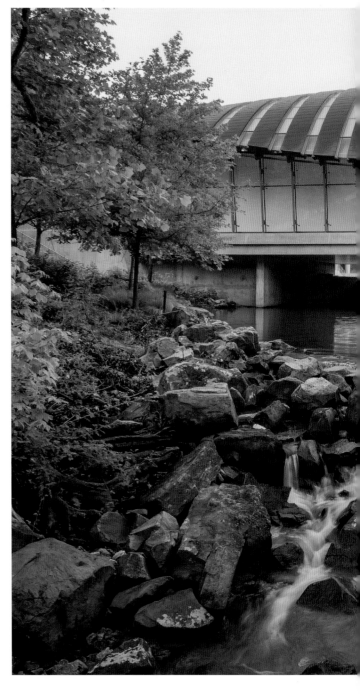

Every day, 500,000 gallons of Town Branch Creek water flows through the Museum on its way to the Elk River in Missouri. Dam structures, called "labyrinth weirs," form the Museum's ponds, pooling water behind them while also allowing it to flow steadily through the campus.

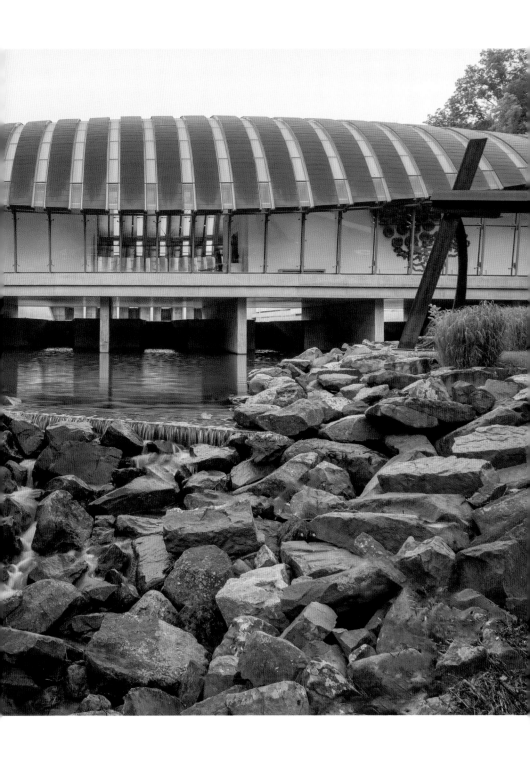

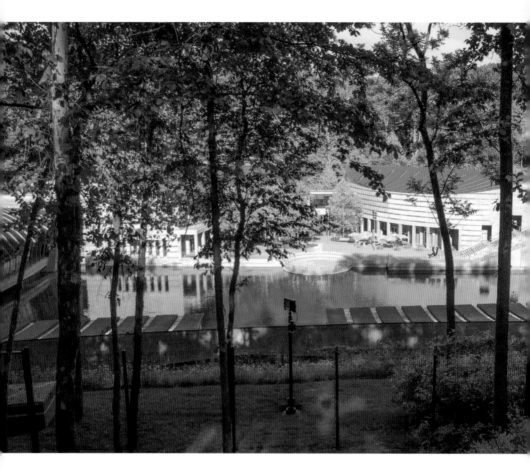

The Overlook, located on the Crystal Bridges Trail to the west of the Museum, is a set of curving stone seats and terraces designed to complement the architecture of the Museum. From here, nearly the entire campus of Crystal Bridges can be seen.

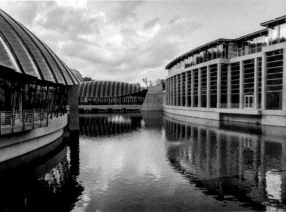

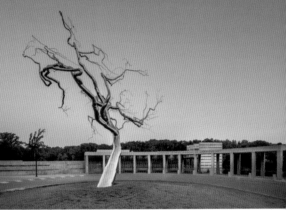

The spacing and rhythm of the colonnade at the Museum's main entrance is repeated throughout the structure: in the columns in the main lobby, the windows lining the Great Hall Corridor, and the copper banding on the roofs. This rhythm of vertical lines references the columns found in classical architecture, reminding guests that the building they are entering houses artwork worthy of architectural exaltation.

"I believe there is a spirituality to the experience of this building and the art and nature as an integrated force. That's what people are so attracted to and what makes people want to come back."
ALICE WALTON

Above: Roxy Paine, b. 1966
Yield, 2011
Stainless steel

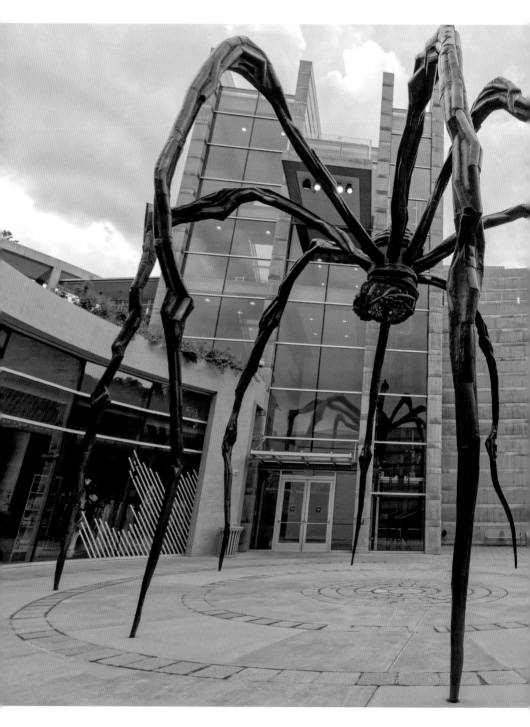

The elevator tower brings guests from the Museum's main entrance down three levels to the courtyard and main lobby. On the way down, guests enjoy views of the Museum campus, the green roof of the Museum Store, and

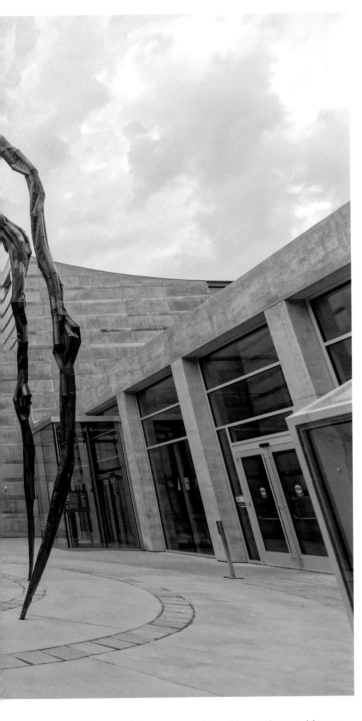

Louise Bourgeois,
1911-2010
Maman, 1999
Bronze, stainless steel,
and marble

Louise Bourgeois's monumental spider sculpture, *Maman*.
From the highest point of the campus (at the entry
colonnade) to lowest (the North Lawn), the elevation
difference is 70 feet, or six stories.

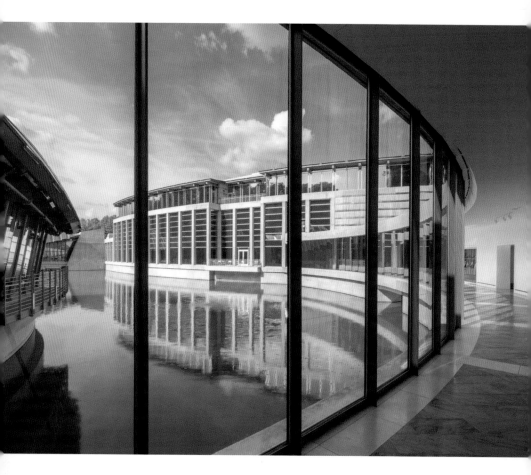

"There are certain themes in Crystal Bridges that I've been preoccupied with for many years, but somehow they coalesced in different ways. One theme is daylight ... the meaning of daylight and the character of daylight."

MOSHE SAFDIE

Safdie is known as a master in the use of light in his designs. At Crystal Bridges, light acts as the connective tissue between the interior and exterior realms of the structure, uniting art, architecture, and nature.

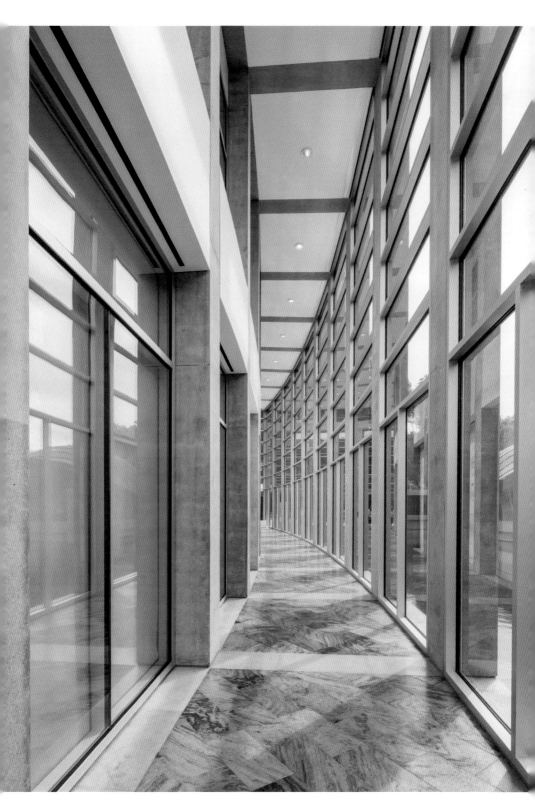

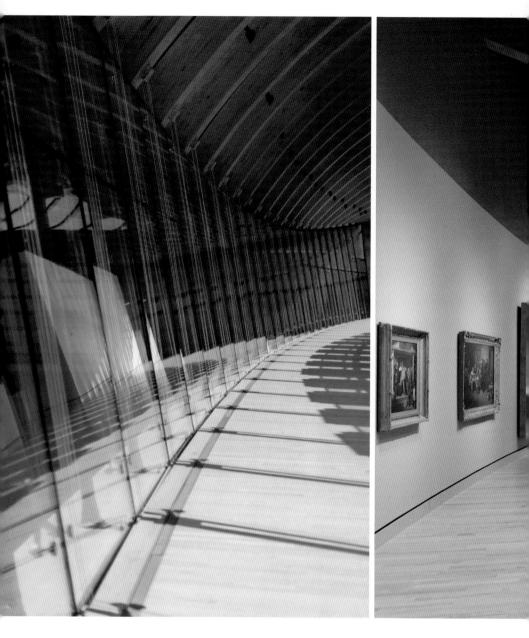

Repetitive patterns of light and shadow, caused by structural beams flanked by linear skylights, produce a rhythmic geometry and suggest a pace at which to move through the building.

Sunlight penetrates the buildings much like it penetrates the tree canopy in the surrounding forest, reducing the "museum fatigue" that can occur in museums due to a lack of exposure to natural light.

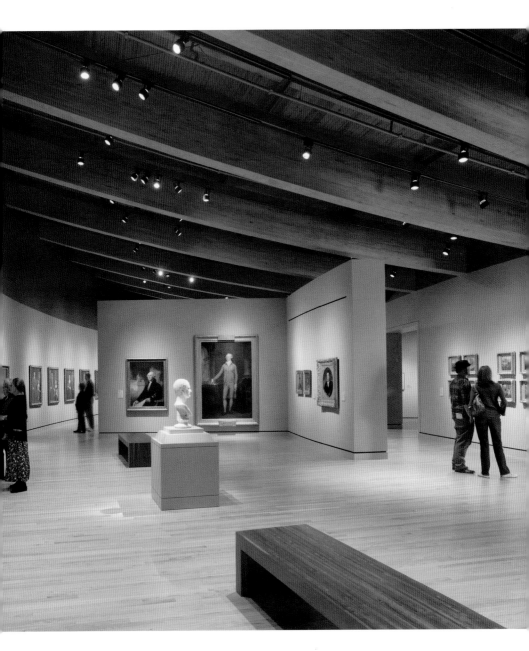

Several of Crystal Bridges' galleries feature unusual curved exterior walls that respond to the shape of the surrounding ravine. The convex walls allow guests to take in a long line of artworks from a single vantage point, heightening the sense of connection among the artworks and drawing guests farther into the space.

"For me, design rooted in place fundamentally requires an effort to create structures that recognize the musical key of their surroundings."
MOSHE SAFDIE

Safdie created interior spaces in an untraditional way, by uniting two engineering systems—the weir system below and the cable suspension system above—with glass. The suspension system supports the glazing, making the roof appear to float above the glass.

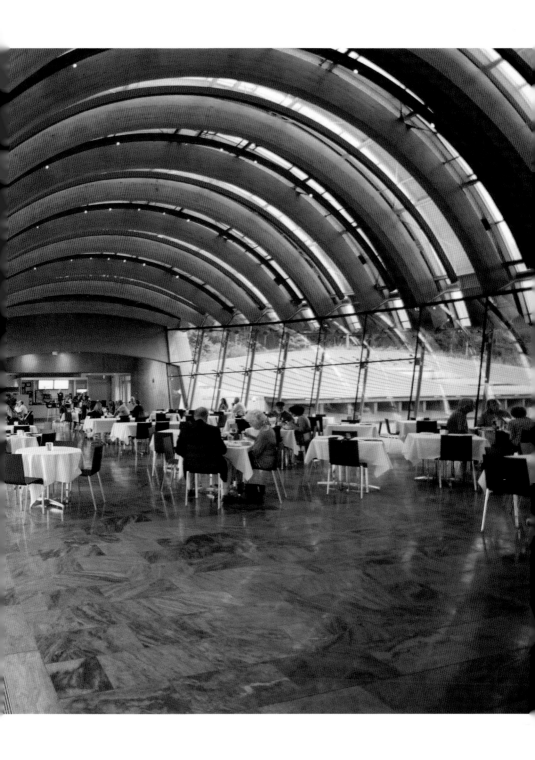

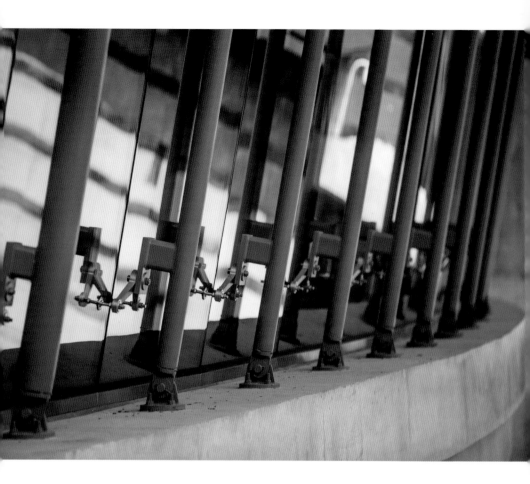

The large glass panels on the bridges are held in place by specially designed "spider" connections (above) that anchor the glass to exterior support struts, eliminating the need for window frames. Since the roof and walls of the suspension structures can shift up to four inches to either side with changes in temperature, the bases of the window support struts are hinged, and the glass panels themselves attach to the roof with flexible accordion joints, allowing the windows to move independently of the roof.

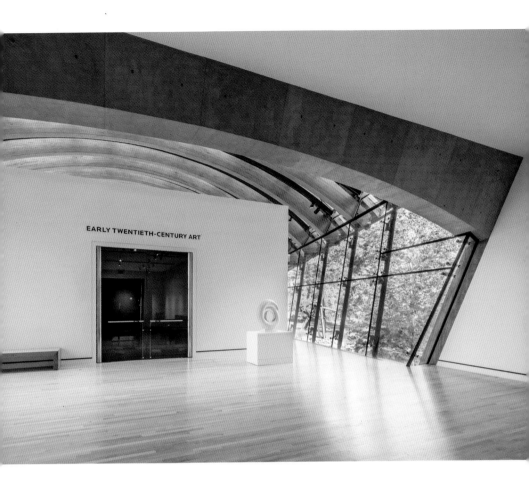

Safdie places great importance on the melding of form and function. The shape of the abutments at either end of the gallery bridge is entirely dictated by the bridge's structural needs. The interior space of the abutments also reflects this shape, reminding visitors that they are inside a built environment and drawing attention to the physicality of the structure.

"I think it was the fact that we were immersed in wood here ... that made me feel that we must build this place out of wood, and wouldn't it be wonderful if that was Arkansas wood. So out of the earth comes concrete, which is banded with wood, and then the structures above us are all made of a very contemporary modern use of wood A very sophisticated structure, but made out of the old materials."

MOSHE SAFDIE

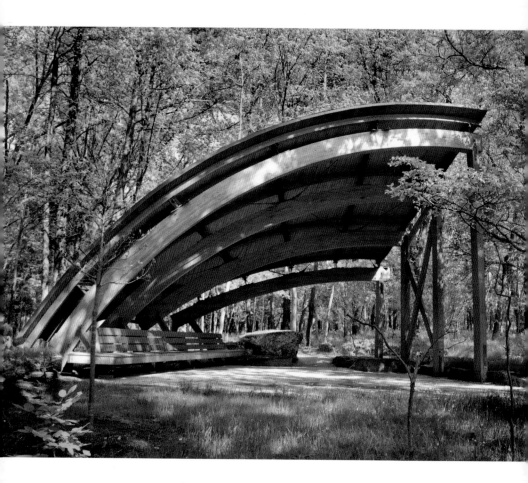

More than 184,000 pounds of copper cover the Museum's roofs. Bright as a new penny when first installed, as in this photograph (opposite), the copper has weathered naturally over time, darkening to a deep brown. Because the air in Northwest Arkansas is low in acidic pollutants, it is unlikely this patina will ever progress to the bluish-green hue of copper in more urban locations.

The roof of the Great Hall is wider than those of the bridges. To ensure that the construction methods would work at this larger scale, a prototype of a one-quarter section of the Great Hall roof was built. This structure was later repurposed to serve as a shelter on the Tulip Tree Trail (above), offering guests an opportunity to get a close look at the glue-laminate beams found throughout the Museum.

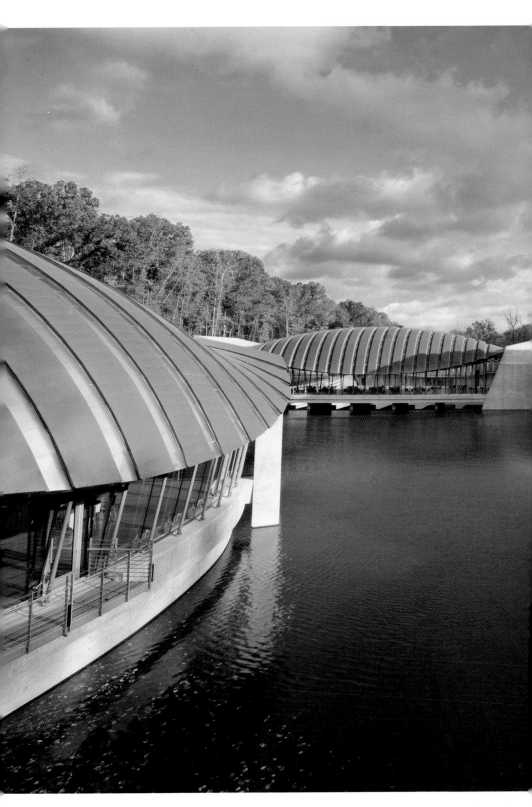

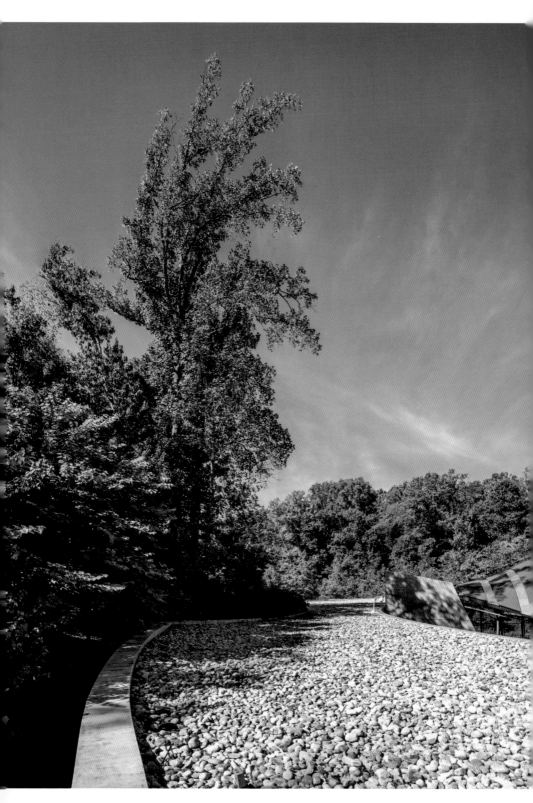

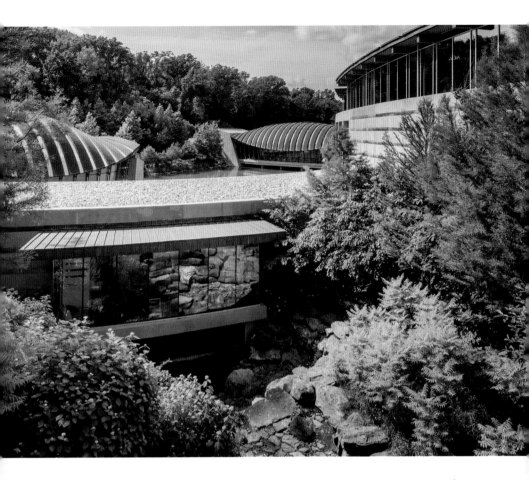

Reflection spaces throughout the Museum provide views
into the natural surroundings (above).

The back side of the Great Hall Corridor shows a semicircular
cutout added to the building's design to accommodate a
pair of mature tulip trees at the edge of the construction site
(opposite). Reluctant to let them be cut down, Alice Walton
asked Safdie to modify his design to spare these stately
trees. Affectionately named "Thelma and Louise" by the
contractors, these trees have become part of the logo for
the Museum's restaurant, Eleven.

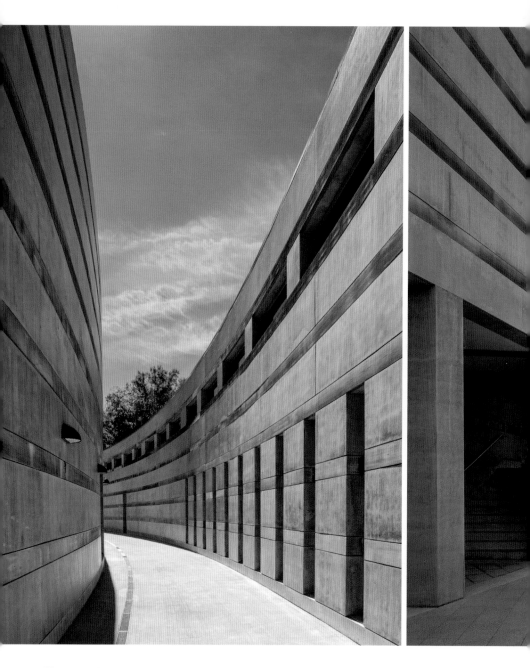

"You can use the concrete as it comes from the mill, and then it's a darkish gray. Or, you can add white cement, and it gets to be prettier and looks a bit like white marble. Alice had strong opinions; let it be raw, and show its muscle-like quality."

MOSHE SAFDIE

More than 45,000 cubic yards of architectural concrete—which has a more refined surface than structural concrete—was mixed and poured at the site.

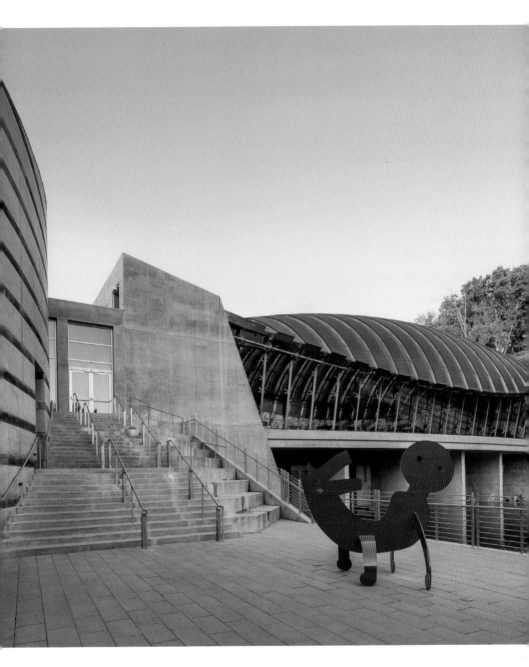

Approximately 20,000 linear feet of red cedar was used to create the decorative banding on the outside of the buildings.

The color of the cedar changes naturally over time, ranging from rich red-gold in protected areas to gray or silver in places where the wood is exposed to the elements.

Keith Haring, 1958-1990
Two-Headed Figure, 1986
Polyurethane paint on aluminum
Made possible by
Sybil Robson Orr and
Matthew Orr

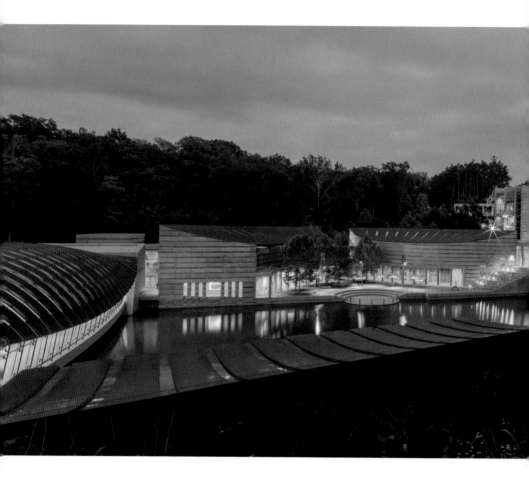

"The sum total, as it has evolved, I think, is more pastoral and more serene than anything I have done."
MOSHE SAFDIE

The presence of water in Moshe Safdie's design enhances the organic feel of Crystal Bridges. By day, sunlight on the Museum ponds casts undulating reflections onto the interior walls and ceilings, reminding guests of the water just outside. By night, the lights from within the Museum are dazzlingly reflected in the ponds' surfaces.

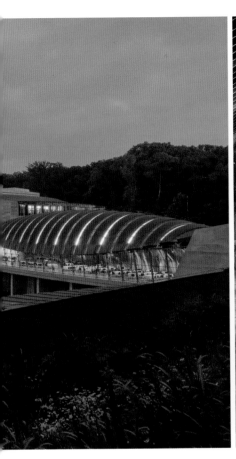

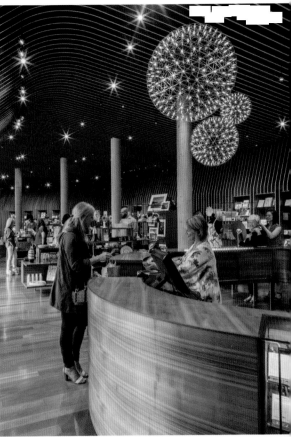

The interior of the Museum Store was designed by
Arkansas-based architect Marlon Blackwell. Inspired by
the fluting on the underside of a mushroom, the design
features curving rows of cherry-wood panels along the
ceiling and back wall. Blackwell's design received an
American Institute of Architects Honor Award for Interior
Design in 2015.

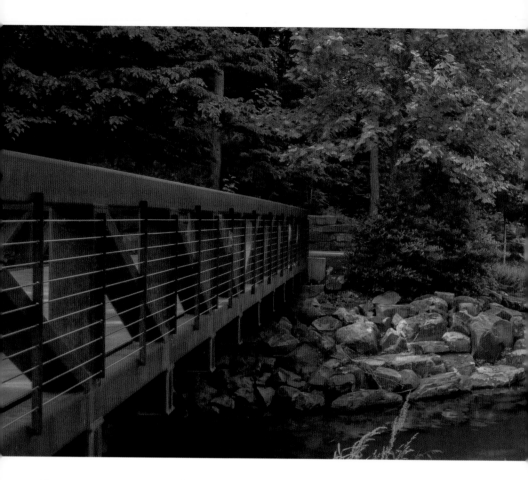

An Architectural Landscape

Crystal Bridges is situated on 120 acres of Ozark forest. Most of the property that now forms the Museum grounds belonged originally to the Walton family. Ten acres of the site, including Crystal Spring, once belonged to Dr. Neil Compton, champion of the Buffalo National River and avocational advocate for native plants, a passion he shared with Helen Walton. Compton collected hundreds of plants from the Buffalo and transplanted them to a site overlooking the spring. Guests on the Museum trails continue to enjoy the fruits of his labors through the azaleas, beech trees, vinca, shagbark hickory, trilliums, and other native plants that were established by Compton and remain to this day.

To Alice Walton and her brothers, the property was a magical world where they explored and adventured throughout their childhoods. When it came time to convert the land into public grounds for the Museum, preservation of this magical quality was foremost.

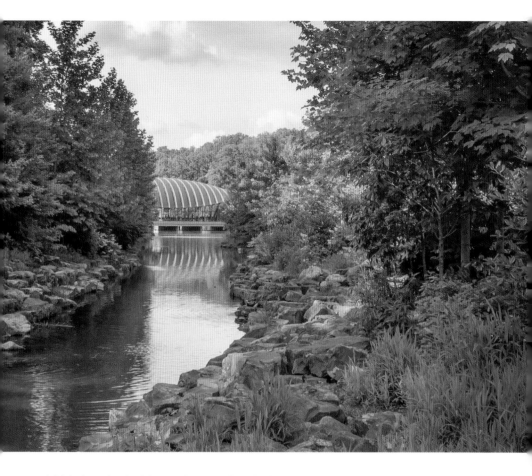

Initial plans for the Museum's grounds included the
"hardscape"—manmade structures such as roads, retaining
walls, and sidewalks. To fill in this plan with landscaping,
and to design the soft-surface trails, the Museum consulted
with landscape designer Scott Eccleston, who later became
the Museum's director of operations. Walton described to
him what she envisioned for the trails at Crystal Bridges: she
wanted guests to have access to the forest, and the trails
needed to remain as natural as possible. She also explained
to Eccleston that she meant to honor Dr. Compton's legacy
by using native plants throughout the Museum grounds.

The Museum's trail system is designed to allow a personal,
interactive experience of the landscape. Tons of native
stone, quarried from the nearby Boston Mountains, were
brought in to create steps, footbridges, and entryways to
the trails, bridging the gap between the steel and concrete
built environment of the Museum with the stone and
wood natural environment surrounding it.

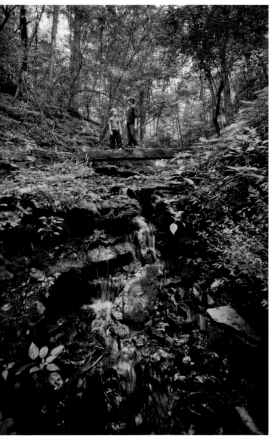
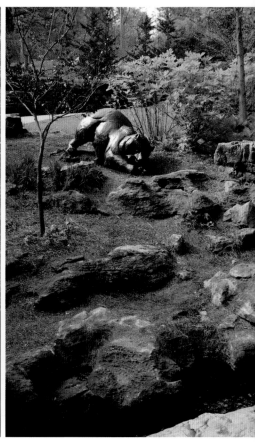

Left: Crystal Spring, located just south of the Museum, was the source of inspiration for the name "Crystal Bridges."

Middle: Cindy Spring on the Crystal Bridges Art Trail

Right: Dan Ostermiller, b. 1956 *Shore Lunch*, 1999 Bronze

The Museum worked with several landscape architects in creating the seven acres of gardens and plant beds on the Museum's grounds. To blend the more formal gardens close to the Museum with the wooded trails, they planted native plants and cultivars in "drifts," large groupings of single species. Drift planting increases the visual impact of native plants that typically grow alone or in small groupings.

Crystal Spring was cleared of invasive non-natives such as privet and Japanese honeysuckle, replanted in native ferns and other species, and made accessible through a curving soft-surface trail that brings guests right to the source, where the cold spring water flows from under a natural stone outcrop. Later, groundskeepers discovered and revitalized several of Dr. Compton's stone-rimmed native plant beds nearby, replanting them with trillium, bloodroot, trout lily, and other regional natives.

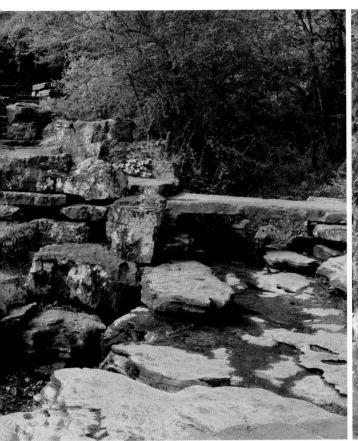

Altogether, some 250,000 plants have been installed on
Crystal Bridges' grounds. Remarkably, a small crew of just
eight groundskeepers maintains the Museum's entire garden
and trail system, as well as 11 acres of manicured lawn.

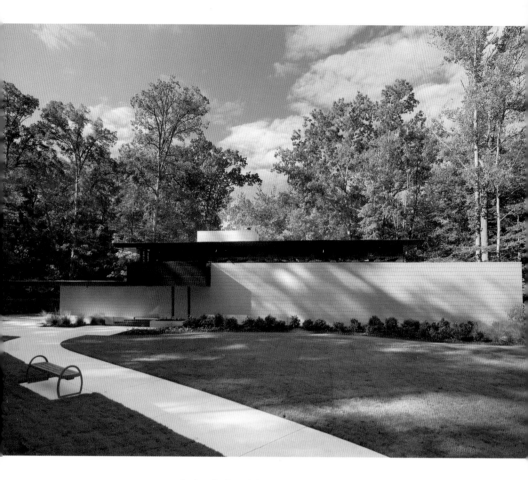

Frank Lloyd Wright at Crystal Bridges: The Bachman-Wilson House

A classic Frank Lloyd Wright house, known as the Bachman-Wilson House, is located just off Crystal Bridges' South Lawn, overlooking Crystal Spring. The structure is an example of Wright's Usonian home, a style of residential architecture he developed during the Great Depression. The word "Usonian" was derived from an abbreviation of "United States of North America." Wright embraced this term as the name for this distinctly American and democratic style. Compared to his highly customized homes, Usonian homes were simpler, lower-cost houses designed to be within the reach of the average middle-class American family, without sacrificing quality.

This house was originally built for Gloria and Abraham Wilson in 1956 along the Millstone River in New Jersey. The "Bachman" in the house name is Gloria's maiden name as well as the surname of her brother, Marvin, who had been one of Wright's apprentices; the Wilsons hoped that including Gloria's maiden name might help them secure

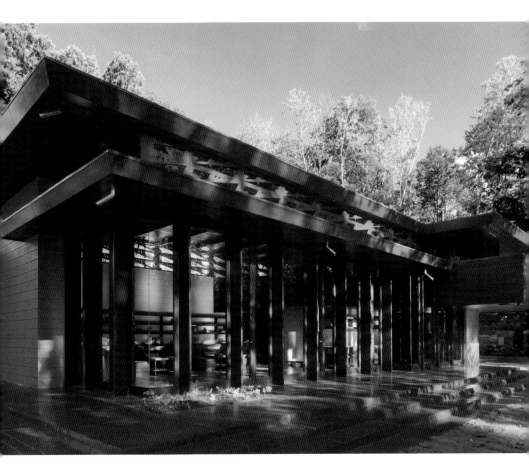

the commission from Wright. The house was subsequently purchased by architect/designer team Lawrence and Sharon Tarantino in 1988 and meticulously restored. However, the structure was threatened by repeated flooding, and the Tarantinos eventually determined that selling the house to an institution willing to relocate it was the best option for its preservation. Crystal Bridges acquired the house in 2013 and, with the support of the Frank Lloyd Wright Building Conservancy, it was carefully documented, deconstructed, packed, and shipped to Bentonville. In 2015 a team of builders painstakingly reconstructed the house on the grounds of Crystal Bridges to ensure its ongoing preservation and to provide access to all.

Usonian Style

Frank Lloyd Wright began experimenting with designs for inexpensive, single-family dwellings in the 1930s, in response to the Great Depression. Like his larger, custom homes such as Fallingwater, in Pennsylvania, Usonian

Opposite: The front of the Bachman-Wilson House, like many of Wright's Usonian homes, presents an unadorned wall to the street, providing privacy.

Above: The back of the house features floor-to ceiling windows and glass doors that open onto the outside. The red concrete of the terrace continues into the living space, further integrating the indoors and outdoors.

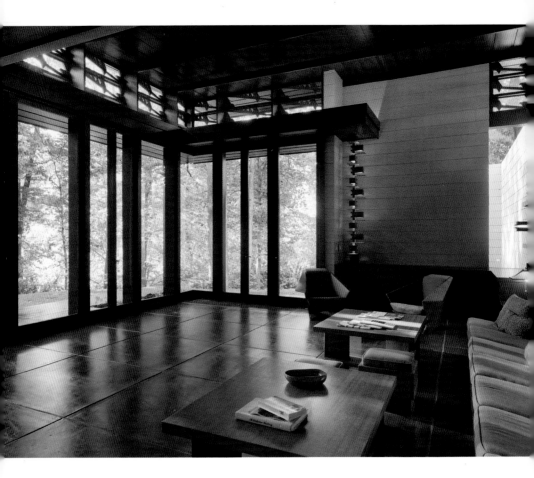

homes expressed many of Wright's design principles: the use of strong horizontal forms, a roof with overhanging eaves, a blend of manmade and natural materials, and a living space with large expanses of glass providing vistas onto the landscape.

Usonians were more affordable than his custom homes because they utilized less-expensive manufactured products, such as cinder blocks, and packed a lot of function into a small space through the use of a modular grid system and an open floorplan. The Bachman-Wilson House, for example, comprises just 1,700 square feet. Approximately 60 Usonian homes were built by Wright and his apprentices between 1936 and 1959, all based on a handful of floor plans that he occasionally modified for buyers. The Bachman-Wilson House is one of these, as a second floor was added at the request of the family, making it a rare "Raised Usonian" design.

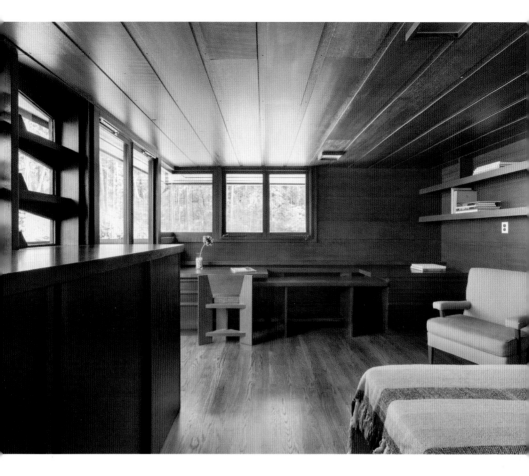

The Usonian home also embodied many of the characteristics we think of today as "green," including radiant-heat flooring, roofs with large overhangs to provide shade, clerestory windows to let in abundant natural light, and large windows in the living area, which allowed for passive solar heating. These features make the homes more energy efficient and help regulate utilities costs.

Opposite: A wall of glass in the living space offers expansive views of the surrounding landscape. Built-in seating and shelves maximize use of space.

Above: The Bachman-Wilson House includes two bedrooms upstairs, rare in a Usonian home. This bedroom offers views through the clerestory windows and the warmth of Philippine mahogany ceiling and walls.

CRYSTAL BRIDGES
MUSEUM OF AMERICAN ART

Text and Photography
Copyright © 2016 Crystal Bridges
Museum of American Art

Book Copyright © 2016
Scala Arts Publishers, Inc.

First published in 2016 by
Scala Arts Publishers, Inc.
141 Wooster Street, Suite 4D
New York, NY 10012
United States of America
www.scalapublishers.com

in association with
Crystal Bridges Museum of
American Art
600 Museum Way
Bentonville, AR 72712
www.crystalbridges.org

Scala Arts & Heritage Publishers
10 Lion Yard, Tremadoc Road
London SW4 7NQ
United Kingdom

Distributed in the book trade by
Antique Collector's Club Limited
6 West 18th Street, 4th Floor
New York, NY 10011
United States of America

ISBN: 978-1-78551-041-0

Printed in China

10 9 8 7 6 5 4 3 2 1

Authors
Linda DeBerry
Robin Groesbeck
Dylan Turk

Editor
Linda DeBerry

Design
Andrea Hemmann/GHI Design

IMAGE CREDITS

Photography by Timothy Hursley: cover, 14, 26, 43

Photography by Dero Sanford: Inside front flap, inside front cover, title page, 4, 26, 30, 33, 35, 37, 40, 41, 46, 47, 50, 51, 52, 53, 54, 55, 56, 58, inside back flap

Photography by Stephen Ironside: 6, 8, 10, 28, 32, 37, 42, 44, 49, 59, inside back cover

Photograph courtesy of the Skirball Cultural Center: 9

Photograph courtesy of the Louisiana Museum of Modern Art: 11

Photograph courtesy the University of Arkansas, Fayetteville: 15

Photography by Eagle Eye Aerial Photography: 16

Photography by Adair Photography: 36

Photography by Marc Henning: 38

Photography by Nancy Nolan: 60, 61, 62, 63